puppy love

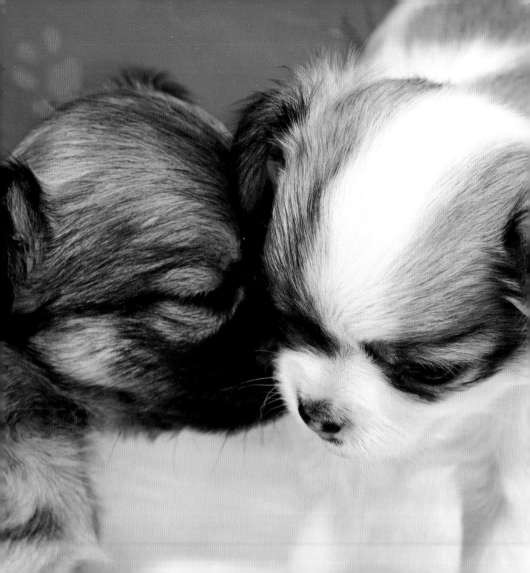

puppy love

how cute puppies meet

STERLING
New York

STERLING
New York

An Imprint of Sterling Publishing
387 Park Avenue South
New York, NY 10016

ISBN 978-1-4549-1133-3

Distributed in Canada by Sterling Publishing
c/o Canadian Manda Group, 165 Dufferin Street
Toronto, Ontario, Canada M6K 3H6
Distributed in the United Kingdom by GMC Distribution Services
Castle Place, 166 High Street, Lewes, East Sussex, England BN7 1XU
Distributed in Australia by Capricorn Link (Australia) Pty. Ltd.
P.O. Box 704, Windsor, NSW 2756, Australia

For information about custom editions, special sales, and premium and corporate purchases, please
contact Sterling Special Sales at 800-805-5489 or specialsales@sterlingpublishing.com.

Manufactured in China

2 4 6 8 10 9 7 5 3 1

www.sterlingpublishing.com

"This bud of love,

　by summer's ripening breath,

　May prove a beauteous flower

　when next we meet."

—WILLIAM SHAKESPEARE,
Romeo and Juliet

HARRY AND SANDY met at the post office; they know that love is a fragile flower to be tended.

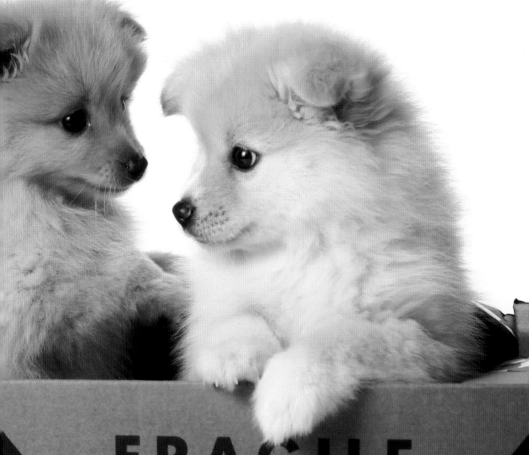

FRAGILE

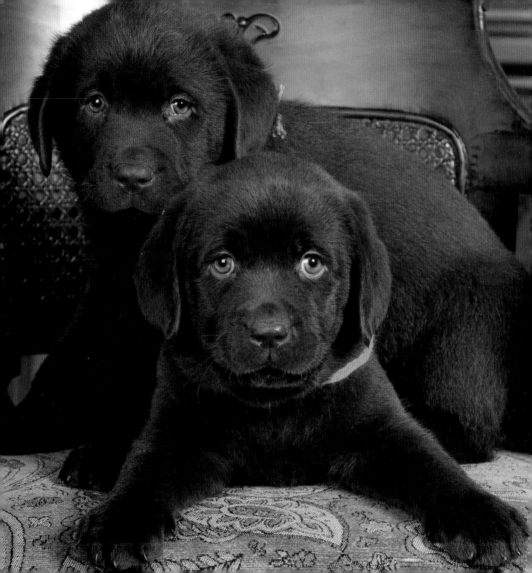

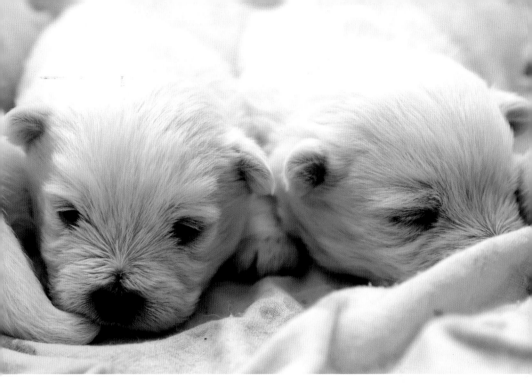

ABOVE: **ANGUS AND MATILDA** "paws" for a little snuggle after meeting under cover.

LEFT: When **CHIP** met **BROWNIE** in the office suite, he had never seen anything sweeter.

MOBY, MOLLY, AND CASEY

met on the farm, but hope to hitch their red wagon to a star.

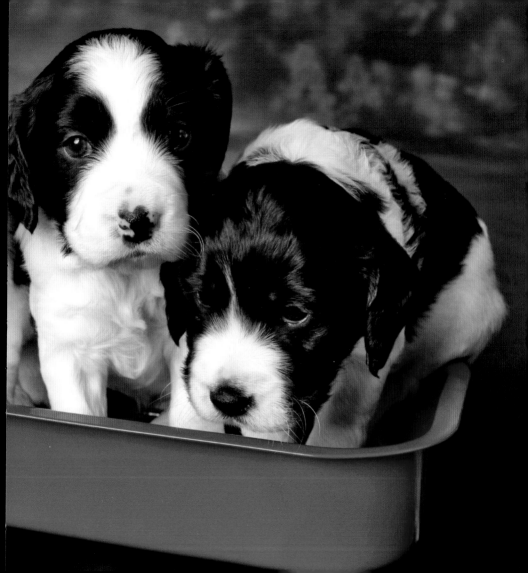

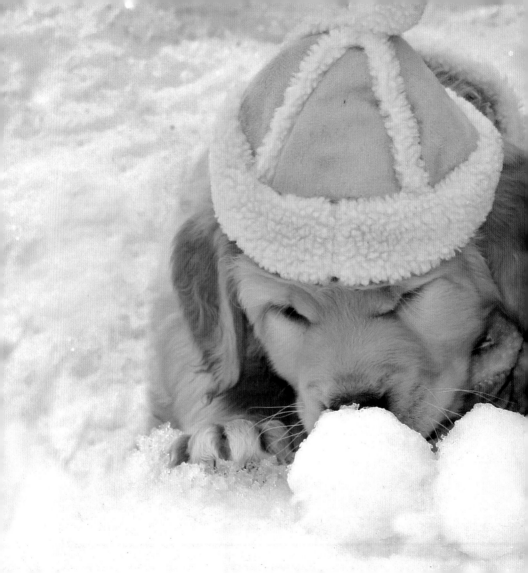

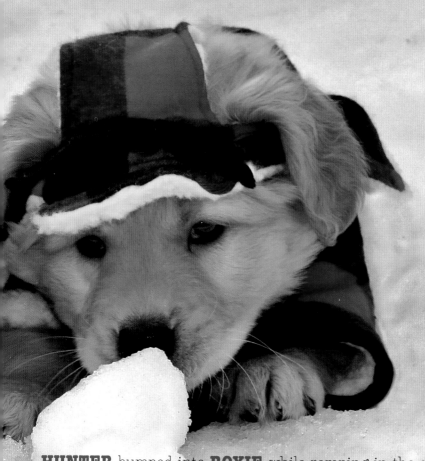

HUNTER bumped into **ROXIE** while romping in the snow.

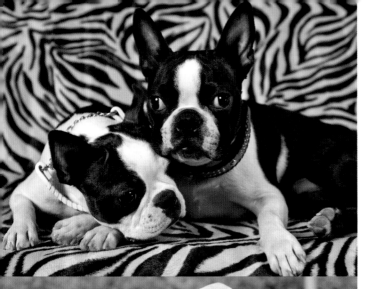

Although **QUINCY** and **COOKIE** met in front of the library, they like to walk on the wild side.

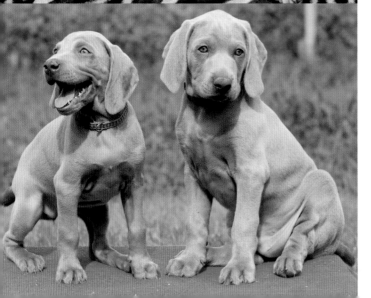

BOOMER fell in love with **BELLA'S** unique shade of gray.

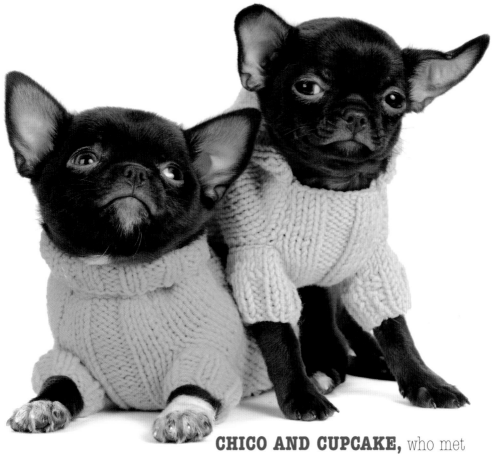

CHICO AND CUPCAKE, who met at the mall, are a close-knit pair.

WINSTON says to **PRINCESS** . . .

meet for dinner at my place?

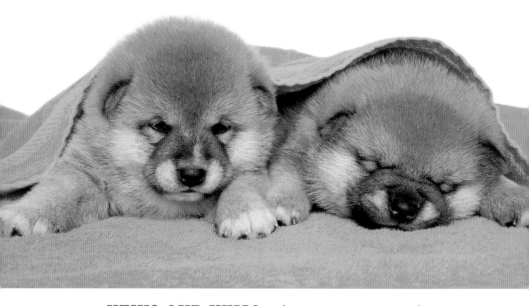

ABOVE: **KEIKO AND KUMA,** who came across each other in a cab, just want to cuddle.

RIGHT: Ever since they met, nothing takes a backseat to **BRUISER'S** love of **BITSY.**

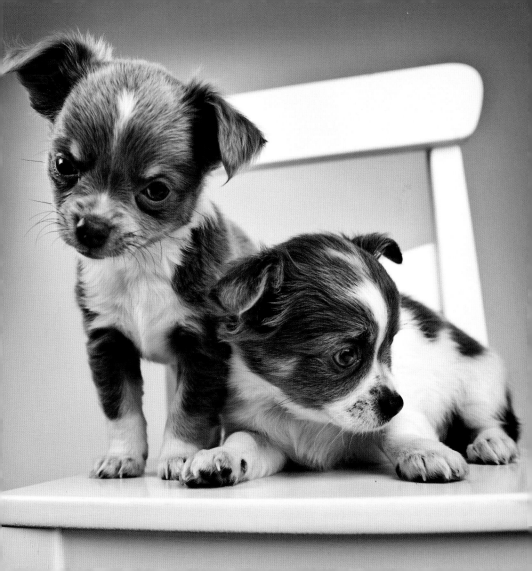

Introduced at the optometrist, **OSCAR AND OPHELIA** believe that beauty is in the eye of the beholder.

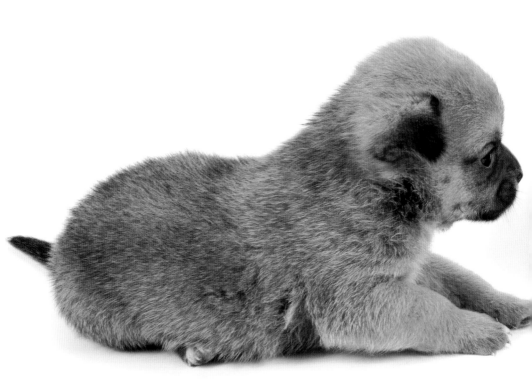

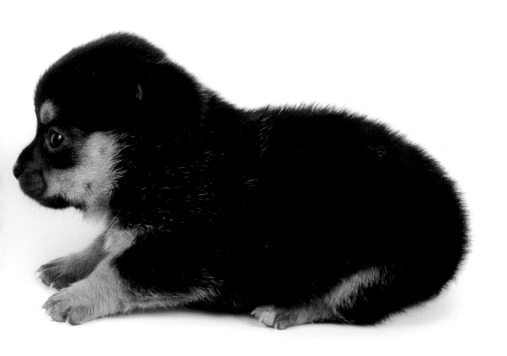

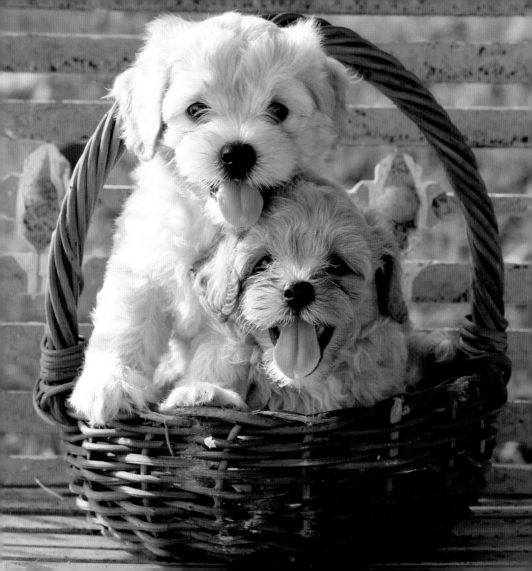

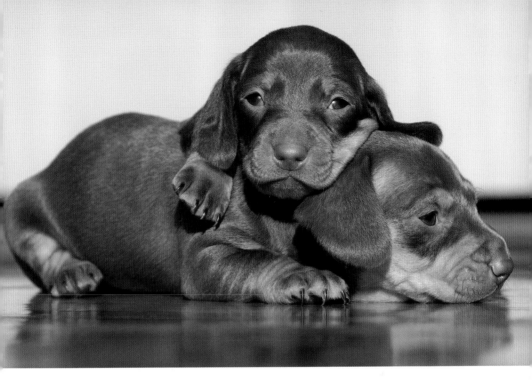

ABOVE: Since **MILO** made **MISSY'S** acquaintance they have been inseparable.

LEFT: A day in the park without **GIGI** would make **CODY** a basket case.

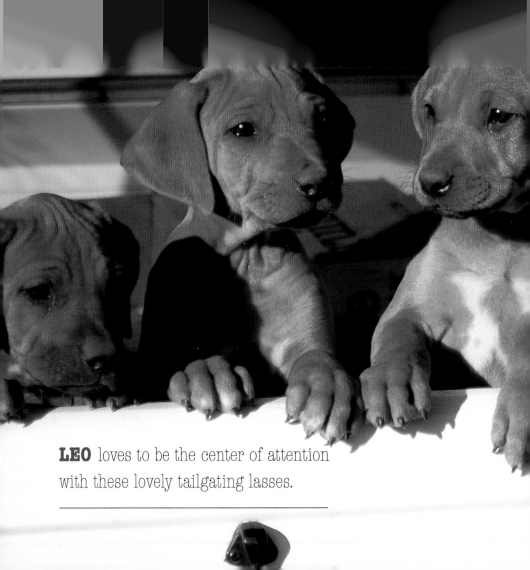

LEO loves to be the center of attention with these lovely tailgating lasses.

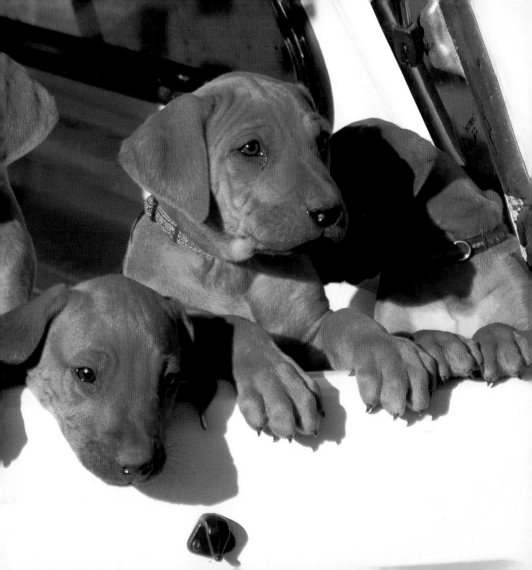

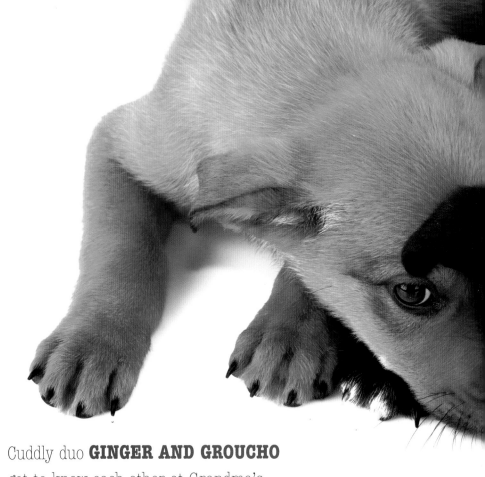

Cuddly duo **GINGER AND GROUCHO**
got to know each other at Grandma's.

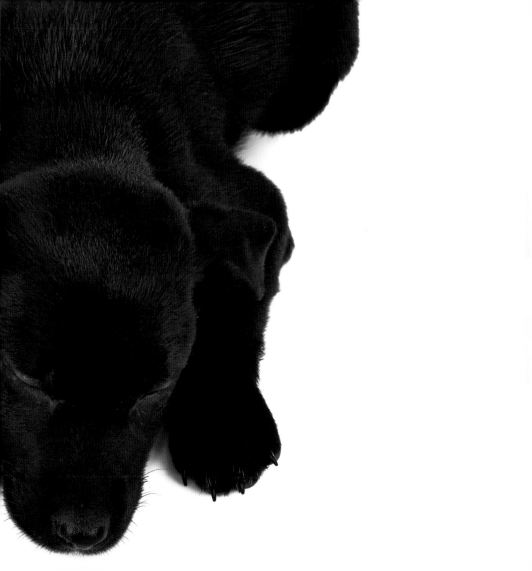

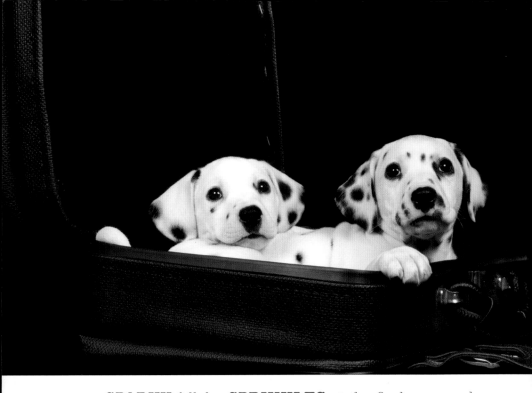

ABOVE: **SPARKY** fell for **SPRINKLES** at the firehouse, and they are always ready to go at a moment's notice.

RIGHT: **FREDA AND FRITZ** met on set; they know how to work the red carpet.

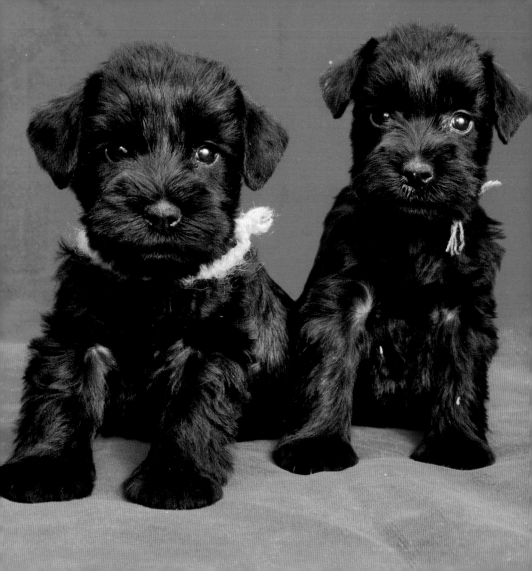

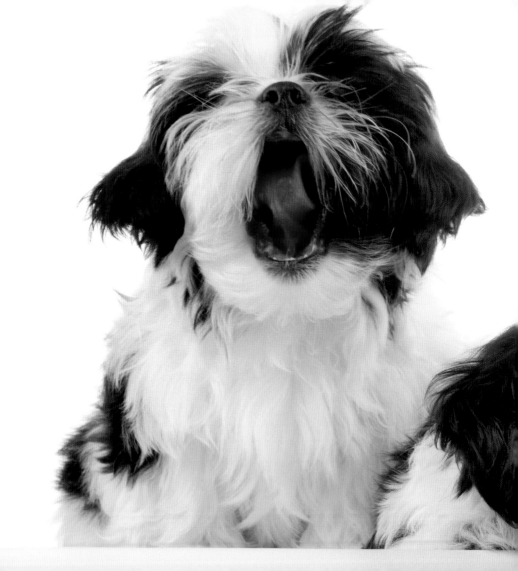

LING-LING yawns while sweethearts **SUKI AND SUMO** snuggle after a long day of play.

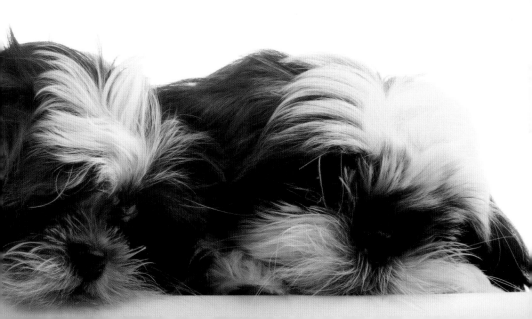

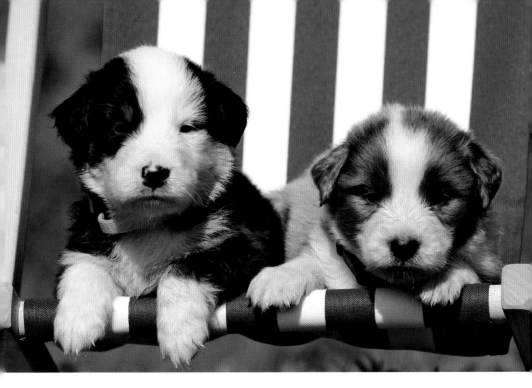

ABOVE: **DAISY** ran into **DUKE** at the cabana; they love hangin' by the pool.

RIGHT: After meeting cute at courtside, **LAYLA** thinks **LEBRAWN** is on the ball.

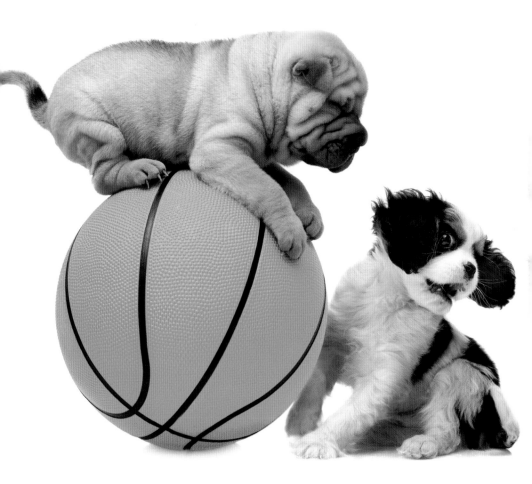

MARTHA spends every Sunday in the park with **GEORGE** playing ball in their special field.

ABOVE: Since meeting in the snow, **MISHKA** has been gaga for **DASHA'S** baby blues.

LEFT: **DEMPSEY** has been dotty for **DUCHESS** since he bumped into her at the dry cleaner.

TOBY wants to cuddle, but **DOLLY** says "I've got a headache—come back tomorrow instead."

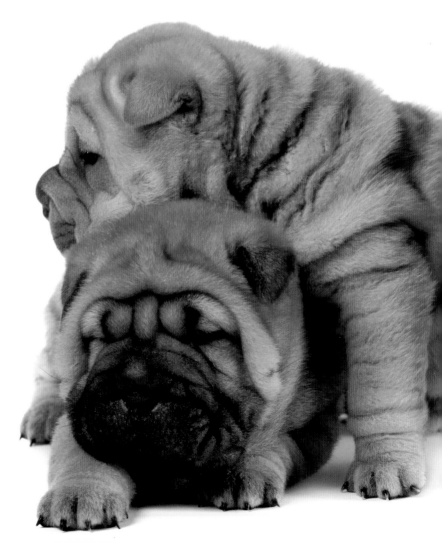

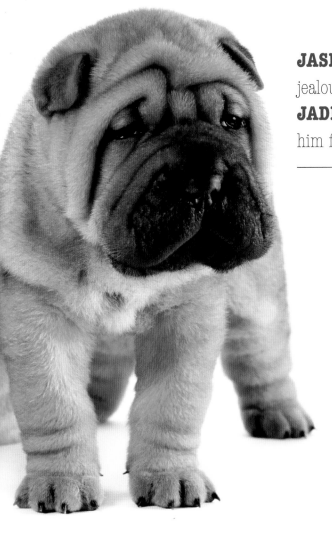

JASMINE gets a little jealous of **JIN AND JADE,** since she met him first at the juice bar.

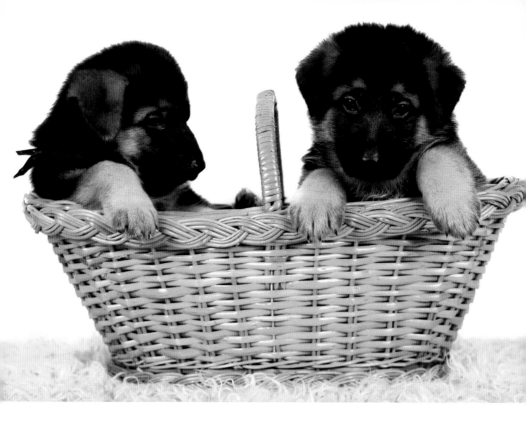

BAILEY gets carried away by **BEAR** after meeting
him at the picnic.

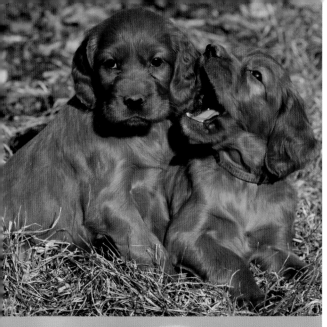

RUSTY whispers sweet nothings into **RORY'S** ear . . . "Have we met before?"

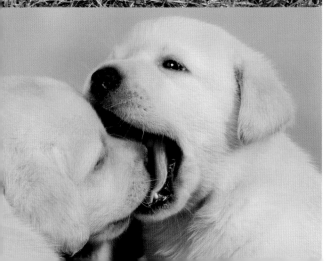

BENTLEY thinks **MOLLY** from Manhattan is super delicious.

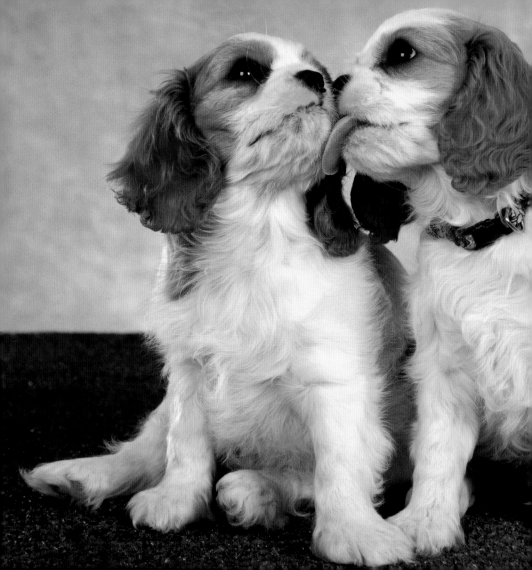

ARTHUR gives **GWEN** a smooch on their one-week anniversary.

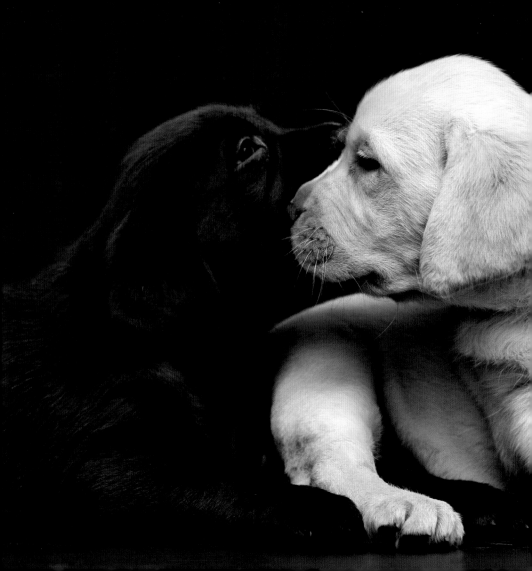

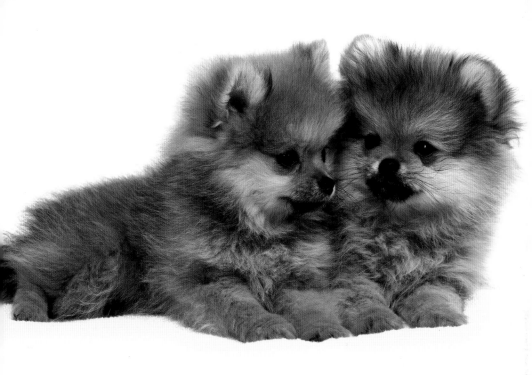

ABOVE: **NAPOLEON** treats **JOSEPHINE** from next door like a queen.

LEFT: **COCO AND NILLA** met at the vet and decide to give it a swirl.

Farm pups **WOLF AND PANDA** steal kisses in the hay.

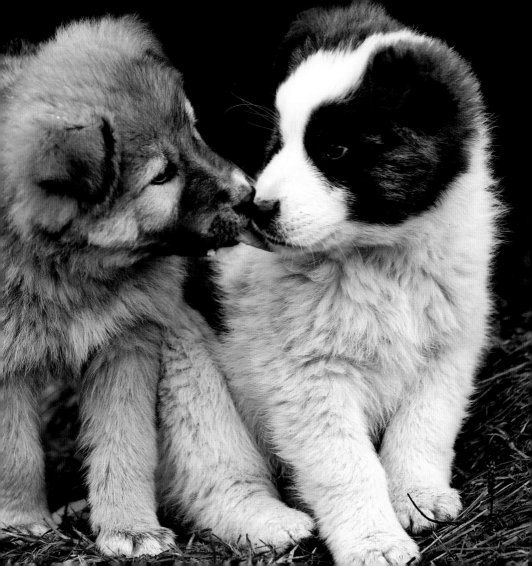

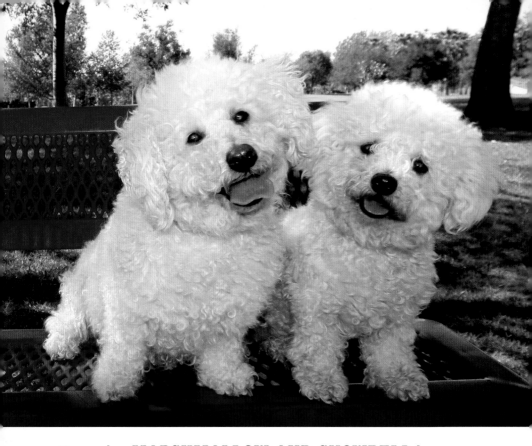

Every day **MARSHMALLOW AND SNOWBELL** have a tête-à-tête at the same red bench.

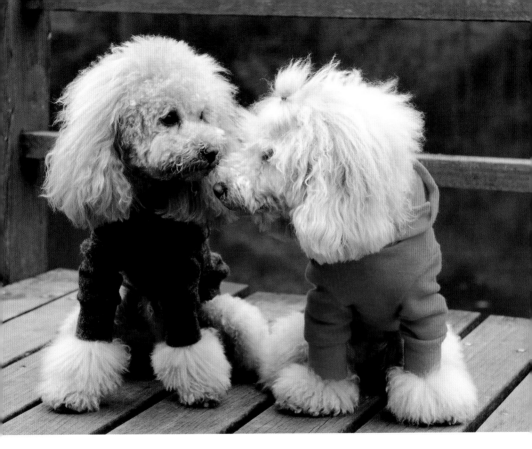

Since meeting at the beauty parlor, **FRANÇOIS AND FIFI**
have bridged the gap.

TARA AND TUCKER met under the table at the taqueria.

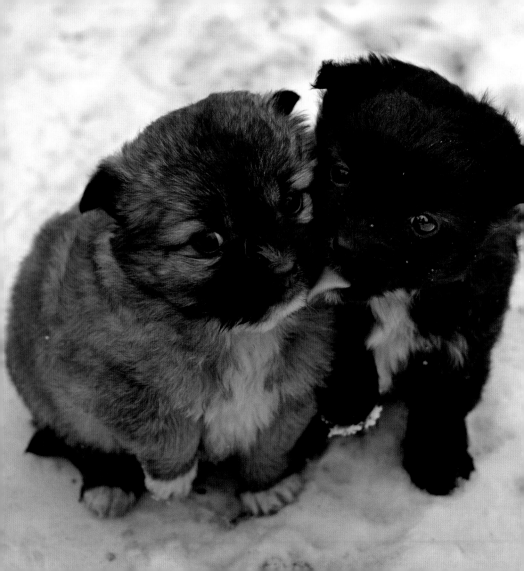

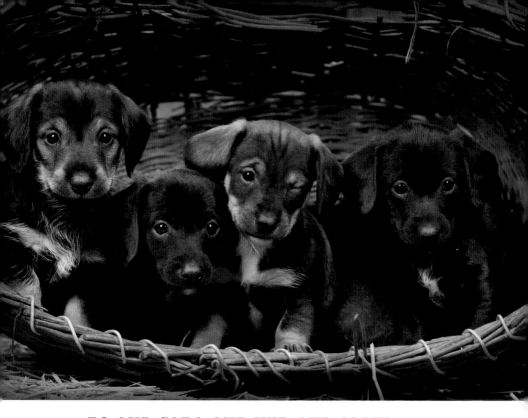

ABOVE: **BO AND CARA AND NED AND ALLIE** enjoy a double dachshund date.

LEFT: Campers **COOPER AND COOKIE** canoodle in the snow.

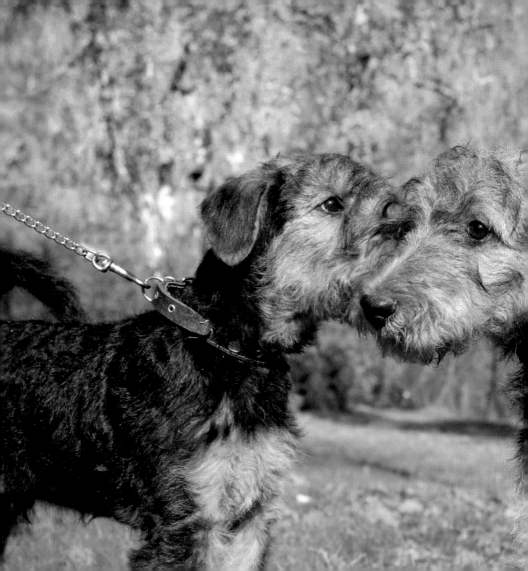

LADY tells **HENRY** to rendezvous by the tree at two o'clock.

COUNT AND COUNTESS, who met during cocktails, are ready for their close-up.

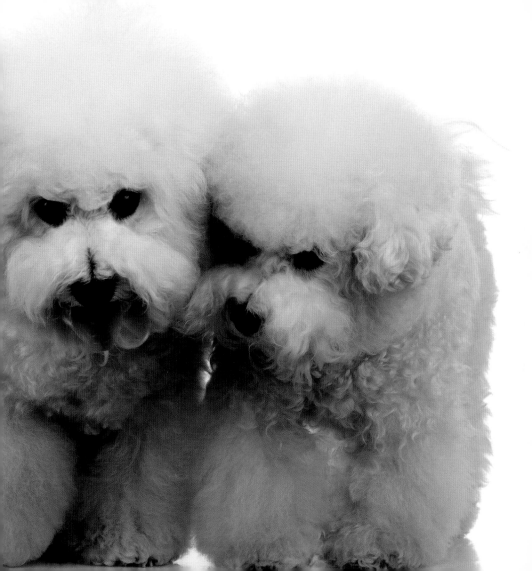

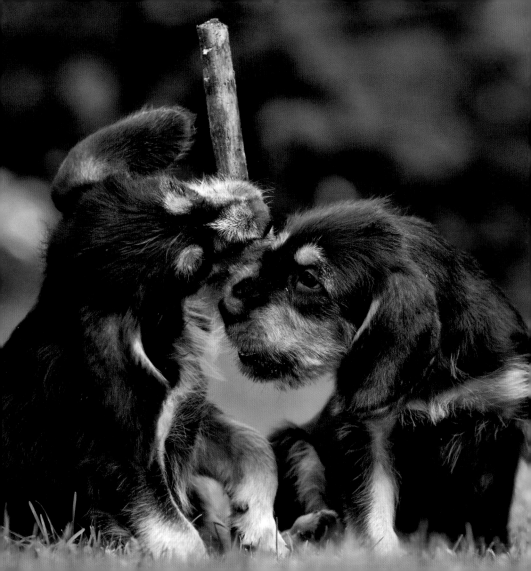

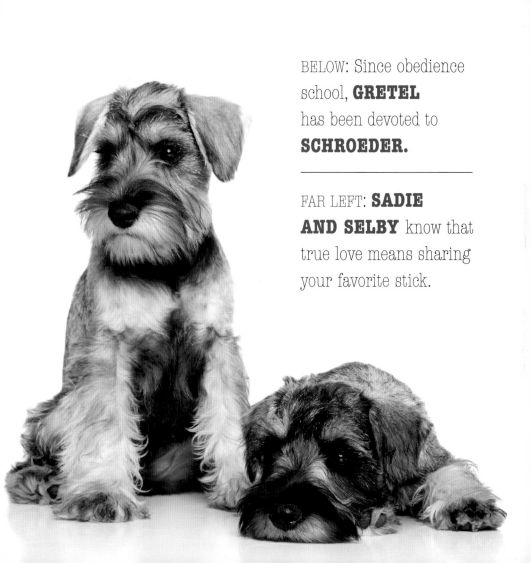

BELOW: Since obedience school, **GRETEL** has been devoted to **SCHROEDER.**

FAR LEFT: **SADIE AND SELBY** know that true love means sharing your favorite stick.

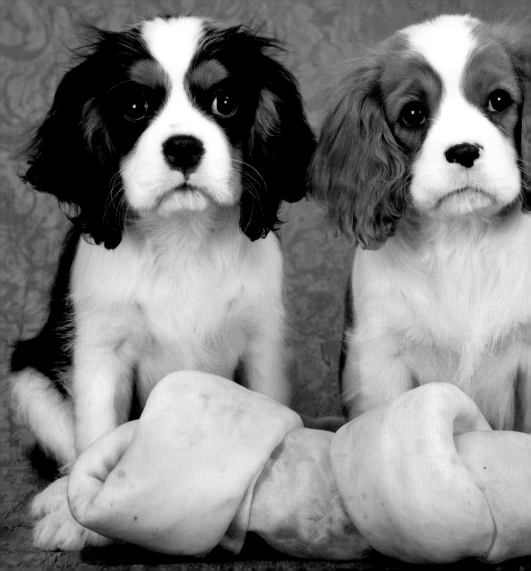

Make no bones about it
—where **HENRY** goes,
TRIXIE follows.

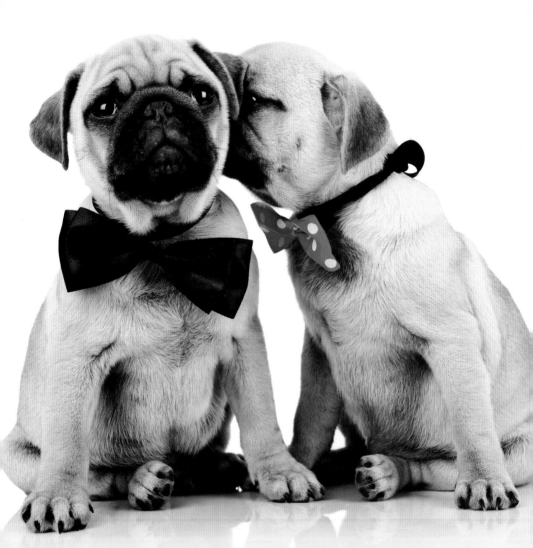

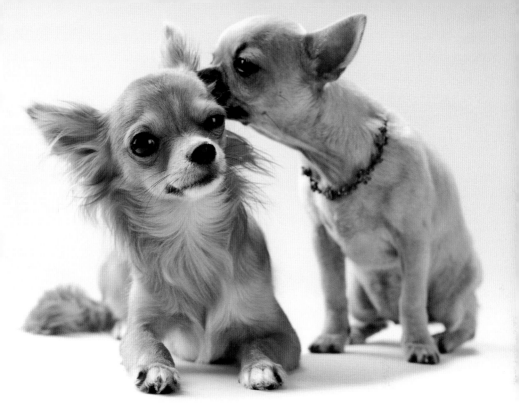

ABOVE: Nuzzlers **NICO AND NONA** met at the nail salon.

LEFT: **COCO AND ZEUS** are dressed to the nines for the New Year's ball.

On their first date, **DELILAH AND RICO** decide to skip dessert.

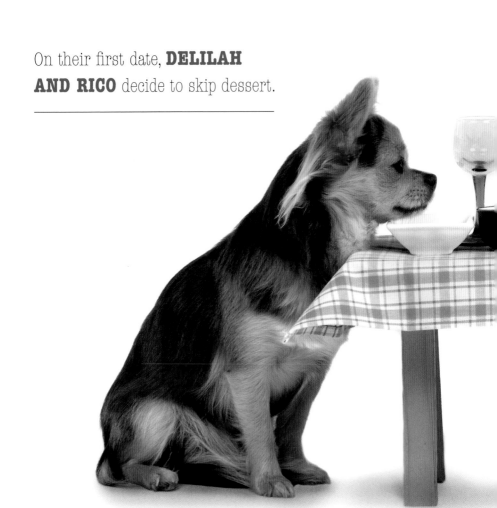

ANNA AND VRONSKY—true sweet "hearts"—were betrothed at the train station.

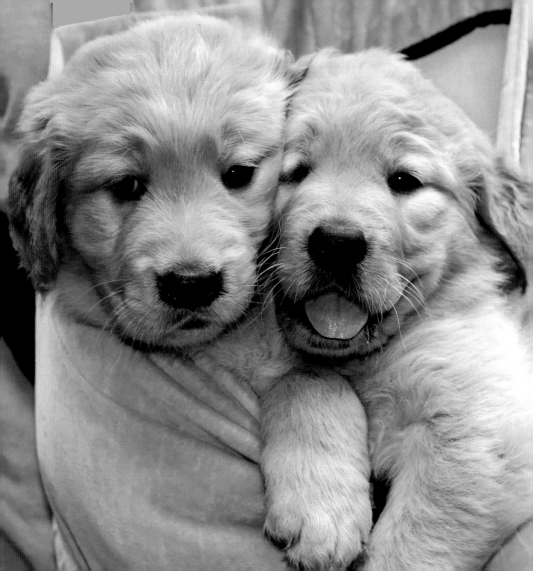

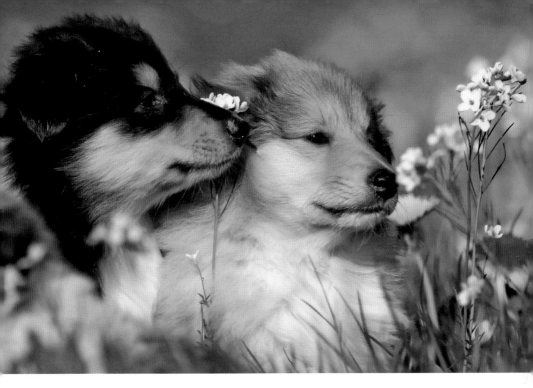

ABOVE: **SAWYER AND IZZY** met in the park, where they always stop and smell the flowers.

LEFT: **DUSTY AND DHARMA** have love in the bag after meeting at the Laundromat.

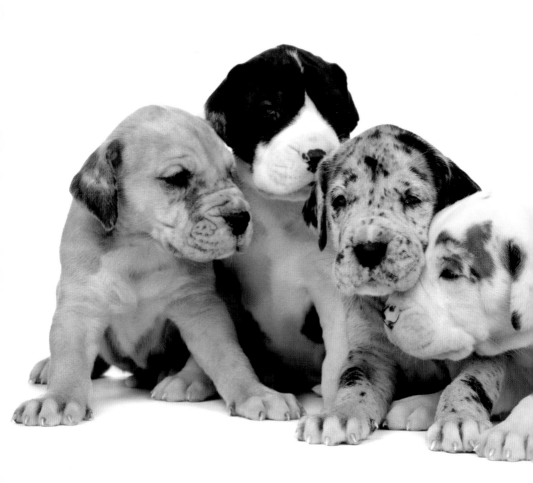

All of the girls love **HAMLET'S** spots
and follow him wherever he goes.

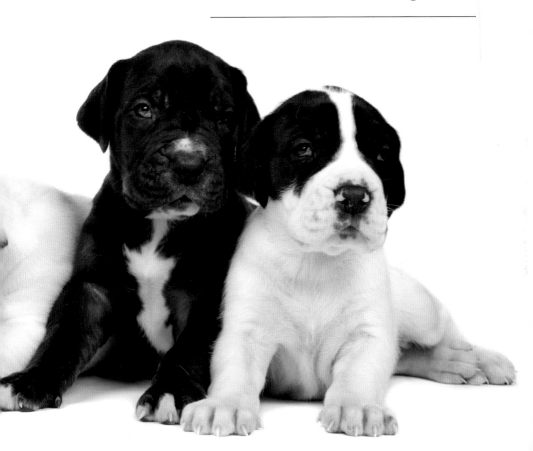

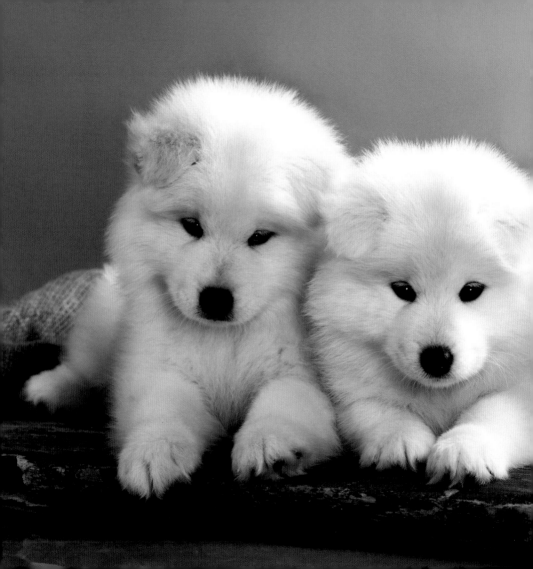

ARAMIS, PORTHOS, AND D'ARTAGNAN, who met at the kennel club, are looking for love.

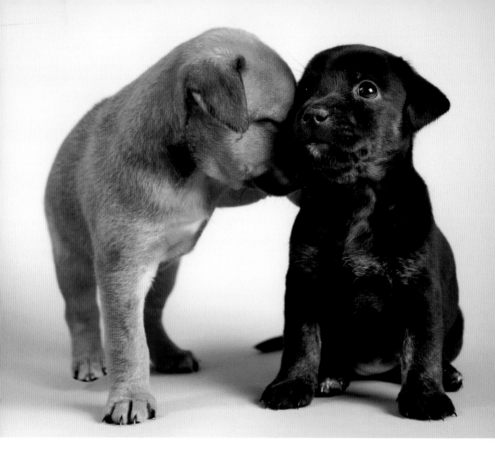

After meeting at a sleepover party, **ALEXANDER AND BELLE** play an intimate game of telephone.

CHLOE AND JACQUES

"paws" for a little snuggle after brunch at the bistro.

BONBON AND BOWZER

met on a walk and are true "sole" mates.

Ballroom partners **FRED AND GINGER**
dance cheek to cheek.

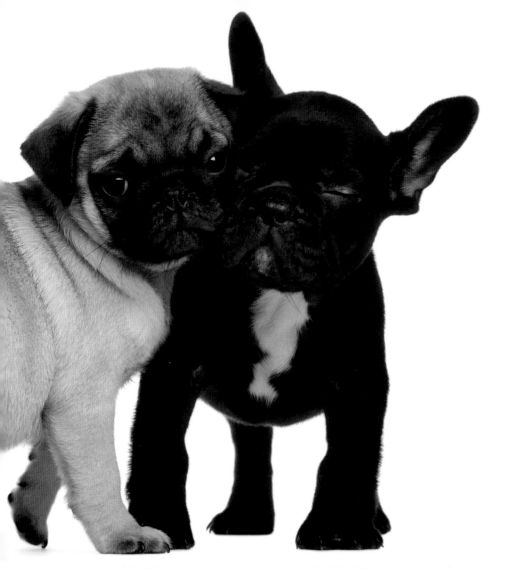

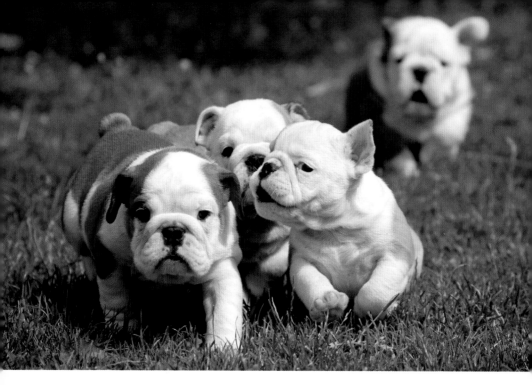

ABOVE: **QUEENIE** always tries to keep up with **CHESHIRE AND GRYPHON,** but they are just mad about **ALICE.**

RIGHT: **SCOTTY AND ZELDA** sleep off a playful night at the mansion.

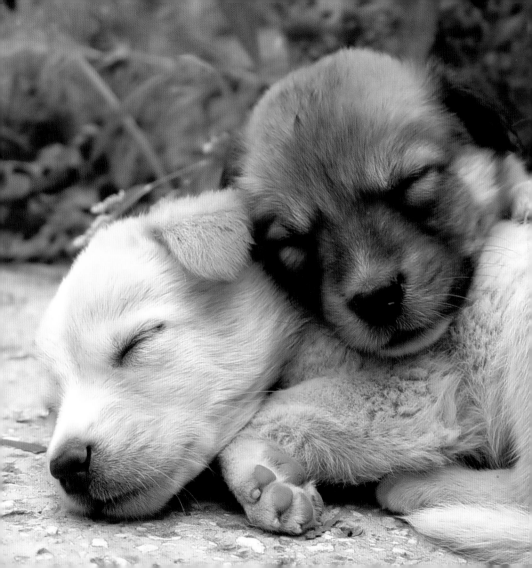

Things have been looking up since **BABYFACE AND BUSTER** became acquainted in the elevator.

Since he arrived on Valentine's Day . . . whatever else anyone says . . . **LUCY** loves **TED.**

Since meeting last Monday, **CAGNEY AND RIPLEY**
see everything through rose-colored glasses.

Roommates since last month, **CLYDE** pulls at **LULU'S** heartstrings.

Beach bunnies **CHICO AND CUPCAKE** love to take long walks on the sand together.

ABOVE: Layabouts **LUCKY AND LEILA** are a counter-surfing tag team.

RIGHT: **ROMEO AND JULIET** know their love is wrong, but they just cannot help it.

GOLDIE AND SUNDANCE

are never more than arm's
length from each other.

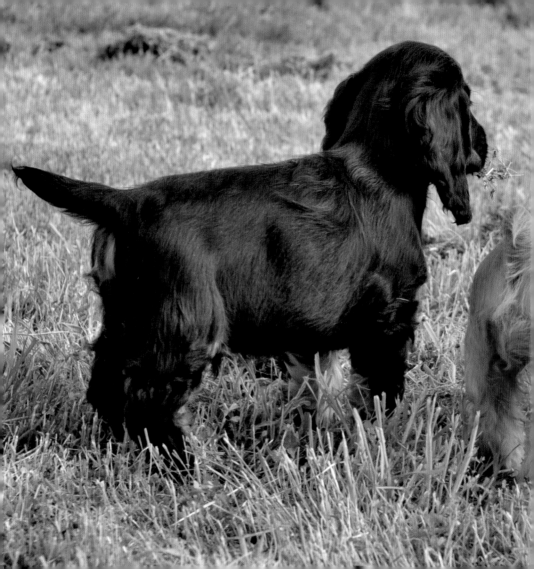

As **JAX AND JOJO** walk off into the sunset together, they know the grass does not grow any greener.

PHOTO CREDITS